BODY ART

THE TOTAL GUIDE TO BODY DECORATION

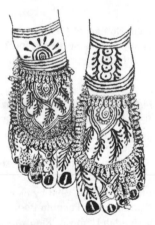

TED POLHEMUS

Illustrated by
SARAH GIBB

EDITED BY MOIRA BUTTERFIELD

ELEMENT CHILDREN'S BOOKS

SHAFTESBURY, DORSET · BOSTON, MASSACHUSETTS · MELBOURNE, VICTORIA

For the next generation - Jesse, Alex, Nate, Evan, Raphael
and my niece Carrie.

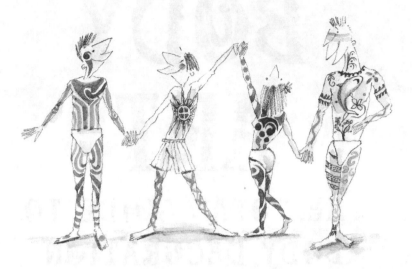

First published in Great Britain in 1998
by Element Children's Books, Shaftesbury, Dorset SP7 8BP

Published and distributed in the USA in 1998 by Element Books Inc.
160 North Washington Street, Boston MA 02114

Published in Australia in 1998 by Element Books Limited
and distributed by Penguin Books Australia Ltd,
487 Maroondah Highway, Ringwood, Victoria 3134

Book and kit conceived and created by Tony Potter Publishing Ltd
Text copyright © 1998 Ted Polhemus
Illustrations copyright © 1998 Sarah Gibb
Design and concept copyright © 1998 Tony Potter Publishing Ltd

The moral rights of the author and illustrator have been asserted.

British Library Cataloguing in Publication data available.
Library of Congress Cataloging in Publication data available.

UK-ISBN 1-90188-124-5

Book and kit designed by Clare Harris and Tony Potter
Printed and bound in Italy

Contents

On pages 92-93 there is a map of the world where you can find all the places mentioned in this book. Look for the symbols like this ➤ to help locate the places.

Introduction

Humans may not be able to run, jump or climb like animals but we are without question the top experts on the planet when it comes to body art.

There's a great example right here in my house. My cats Buster and Pris look the same every day. They are "Russian Blue" cats with beautiful silvery fur, but apart from their color they have no other decoration. They never wear make-up or jewelry (not even cat collars). It's true that they do have tattoos - identification numbers put in their ears by the vet when they were kittens. But this certainly wasn't their idea. They don't behave the same as we humans when it comes to appearances.

So what do Buster and Pris think of me? When I'm getting out of the shower I'm one color all over. But when I've put my clothes on I'm all sorts of different colors. My partner Catherine is even more confusing. As well as wearing clothes in different colors and shapes, she also likes to wear wigs - one is black, one is bright blue, and another is shocking pink. She's just dyed her own hair VERY bright red (like a fire engine) and she has painted a beautiful henna design* on her feet. Somehow Buster and Pris realize that she and I are the same people whatever we look like, but they must think it is very strange that we humans keep changing our color and our "skin."

If they could ask questions they might want to know why we change ourselves and how we do it. If they could read this book they could find some of the answers.

* See page 32 for information on how you too can paint henna designs on your body.

We're Special

They say that "A leopard can't change its spots". It's true. Like Buster and Pris this distant relative of theirs could not, for example, choose to have the stripes of a zebra. However, there are some animals that can change their appearance in seconds. The chameleon, a little lizard from parts of Africa and Asia, can almost instantly become darker or lighter or change color completely in response to changes in the amount of light, the temperature, or even its emotions.

Chameleons change color in order to hide. If they are sitting in a shady place they become brown. If they move to a brightly-lit spot then - hey presto! they go bright green or yellow. A chameleon lying behind a fence will become striped! This very neat trick provides them with a natural camouflage. Even up close other, bigger animals that like to eat chameleons might think they are just tree branches, rocks, or something else that tastes terrible.

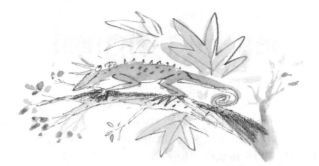

But while it is true that a chameleon can choose to sit in a shaded or a bright spot it cannot choose what color to be. Unlike you and me, a chameleon doesn't wake up and think "Should I be brown or green or yellow today?"

What is special about us human beings is that we <u>decide</u> what we are going to look like. Then we do the most amazing things to transform our bodies into the picture that we have in our minds.

Sending Signals

The human being is the only animal I know of on the planet that decides what to look like and then transforms its appearance by decorating itself. At least, that is, on Planet Earth. If a spaceship from some distant galaxy landed on your street tomorrow, do you think the creatures that got out would wear jewelry, body paint, spray their hair silver, or paint little designs on all of their 124 toes and fingers?

I think they would!

Why?

Because body adornment (decoration) is a kind of language which allows a person, or maybe a space creature, to express him- or herself. It's a very clever way to instantly tell other people (especially complete strangers) about yourself. It's one of our greatest inventions and I'm sure any creature intelligent enough to travel across space would realize this.

What does your appearance say about you? What is most important to you - to look attractive, intelligent, fun, serious, interesting, sporty, unusual, or normal?

Whether we like it or not our appearance is never "silent." It's always sending signals about our personality.

Is your appearance sending signals? Think about what they might be after you've read this book.

What is Beautiful?

Recently I was in a supermarket when I saw a woman with a shaved head, a ring through her nose, a tattoo design on her arm, and LOTS of black eyeliner and lipstick. She had her small child in the shopping trolley. Does your mother look like this? How would you feel if she did? Do you think this sort of body decoration is attractive or ugly?

However you react, it's certain that somebody somewhere in the world would disagree with you. Different people have different ideas about what kind of body decoration is beautiful. This is true in the supermarket, at school, and all around the planet. Those "appearance signals" we give out change, depending on who's receiving them.

On the next few pages there are some examples of body adornment from around the world. See how you react to each one. Do you think they sound beautiful or not?

Skin-greasing

In many parts of Africa it is thought that an attractive girl should have really shiny, even greasy, skin. In the south-western part of Ghana* a young woman, shortly before she is married, is ceremonially bathed in the river and given instructions in the things she will need to know as a wife and mother. Then butter from a certain kind of nut is smeared all over her body, she is wrapped in beautiful cloth (which covers the lower part of her body but not her breasts) and adorned with precious gold jewelry before being paraded through the village.

Of course, the young men of the village want to marry her because she is so shiny, greasy, and attractive.

Imagine covering yourself with peanut butter. Do you think it would look nice? Would you use "crunchy" or "smooth?"

In many parts of Africa girls and women will coat their bodies with the fat from animals. If a woman has no animal fat to make herself shiny she will be ashamed to go out because she believes her dry skin is terribly ugly.

On pages 92-93 there is a map of the world where you can find all the places mentioned in this book. Look for the symbols like this to help locate the places.

* *For Ghana, see* 🏃 *on the map.*

Teeth-filing

On Bali*, a little island in Indonesia in the South Pacific, they believe that a beautiful woman or a handsome man must have perfectly straight flat teeth. For this reason, when a girl or boy becomes a teenager he or she is taken to a special person in their village who will file off teeth points to make them smooth and flat.

There is no anaesthetic and this tooth filing is REALLY painful. It is a kind of test, an initiation. If you can stand it without screaming or crying too much then you are thought ready to become an adult. As a bonus you get really flat teeth, which is important because the Balinese believe that teeth with pointed edges make you look like an ugly wild animal.

Do you think your teeth look nice? Do you think they would look better if, like some Rap musicians, you had a gold tooth with diamonds in it? Actually this isn't anything new. More than 500 years ago the wealthy people of the South American Inca Empire in the Andes mountains* had gold inlaid in their front teeth.

*For Bali, see 👄 on the map.
*For the Andes Mountains see 👃 on the map.

Neck-lengthening

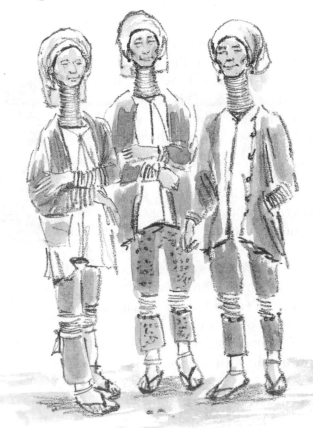

In Myanmar* (Burma), in Southeast Asia, there is a small but ancient group of people who are called the "Padaung." They believe that a woman can only be really beautiful if she has a long neck. I mean a VERY long neck. Now you might think that you are either born with a long neck or a short neck and that there's nothing whatsoever you can do about it. But you would be wrong.

At around the age of 12, a Padaung girl has heavy metal rings fitted around her neck. These are piled up until they are squeezed tightly between the chin and shoulders. Each year more rings are added and very, very slowly their weight pushes the shoulders down, in this way making the neck look longer.

A Padaung woman will wear her neck rings all her life, never once taking them off. If she wants to scratch an itch on her neck, it's just too bad. It must be a lot of work carrying all that metal around. But for the Padaung this is the price to be paid for beauty.

For Myanmar (Burma), see 🔖 on the map.

Hairstyling with clay

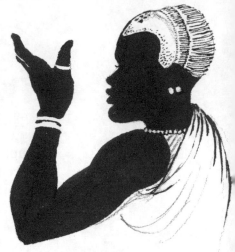

Among the Hamar peoples* of Ethiopia exotic hairstyles are very important. Girls and women are especially attracted to boys and men who have a hairstyle known as a boro. This is made by covering most of the hair with clay, smoothing it over, pricking holes in it so that, when the hair grows underneath, it doesn't crack, and then painting the clay white, red, and blue. At the front, over the shaven forehead, some special holes are made. These are used, on special occasions, to attach a large ball made of feathers. More feathers may be inserted at the back of the head.

The only men who are allowed to wear this hairstyle are those who have either killed an enemy in battle or have killed a dangerous animal such as a lion or a leopard.

The Hamar girls, on the other hand, rub animal fat into their hair, roll it into tight little balls and then paint it with bright red clay.

*For Ethiopia see 🗺 on the map.

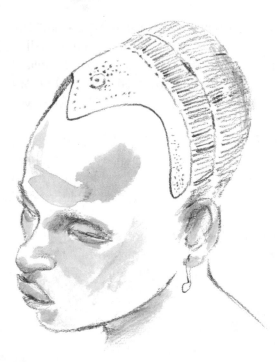

Corset-wearing

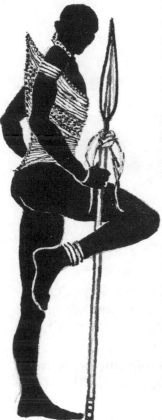

Nearby, in the Sudan*, there is another tribe called the Dinka. Here it is the waist rather than the hair which is the focus of male attractiveness. The young men of the Dinka tribe wear corsets, each one made from thousands of tiny colorful beads. These corsets are sewn around the boys and they press tightly around their waists. They are not removed for several years, when they are replaced by one of a different color, a sign that a boy has become a man.

The males of the Dinka tribe wear no clothing other than their colorful corsets. The parts of the body which we always cover in public are exposed for all to see. However, if for some reason a Dinka man's corset should come off when he is in public and expose his waist he would feel the same way you would if you dived into a swimming pool and your costume came off. Also, of course, without the corset to tightly pull his waist, a Dinka man would be considered to be very ugly.

For the Sudan, see 🐢 on the map.

Given the choice would you prefer to:
1) smear your body with a greasy butter made from nuts,
2) have your teeth filed flat,
3) get your neck stretched,
4) have your head covered in colorful mud, or
5) wear a tight corset?

If you picked 3 - stretching your neck - I'm afraid that you are probably already too old as your bones have got too firm and inflexible. So ... get out the peanut butter!

If you want flatter teeth, visit your dentist or talk your family into going on holiday to Bali where, if you are very brave during your teeth-filing, you will be given presents of uncooked rice and a new pillow.

What is Normal?

By now you'll have gathered that human beings are very strange. Unlike animals we take the bodies we are born with and set about changing them as much as possible. And what's more, we've been doing it for a very long time.

Thousands of years ago some of our Neolithic ancestors were buried with pots of brightly-colored paints, presumably so that they could change their appearance even after death.

Five thousand years ago a man in the Alps* was climbing a mountain, died and got frozen in the ice. When, a few years ago, his body was found and thawed out it was discovered that he had tattoos on his skin.

Three hundred years ago, in the seventeenth century, rich men and women wore fantastically complicated wigs, powdered their wigs and faces white and stuck little black fabric patches shaped like stars and moons onto their faces (more often than not in order to cover up scars caused by diseases such as smallpox).

*For the Alps, see 🏃 on the map.

Today, in my supermarket, and probably yours as well, there are people with tattoos, painted faces, rings in everything from their ears to their eyebrows and strange haircuts. There are also people who look "normal."

So what is "normal?" It depends on where you live and what era you live in. In the countries I've talked about, neck rings, greasy skin, or corsets are considered normal. Maybe in a few years where you live, there will be more people with tattoos and piercings and strange haircuts than people without. Then, if you want to look unusual, you will have to stick to what today is seen as "sensible" body decoration - a nice neat haircut and a ring or two on your fingers.

Are you the sort of person who likes to stand out from the crowd and get noticed? Or are you the sort that prefers to blend in and "go with the flow?" Whichever you choose it's important to remember that neither is "better" or "worse" than the other. It's just a matter of personality.

What Do Other People Think?
(and does it matter?)

Humans start with one look and then have the option of changing it. This is part of what it means to be a human being - to be able to change your appearance. Everyone's doing it in lots of different ways. Easy, huh?

Well, no, it's not so easy. Even when we are adults we still have to make a balance between what we <u>want</u> to look like and what other people think we should look like.

A friend of mine used to work in a bank but lost her job because her boss said that her punky-looking hairstyle was "too unusual" and would frighten away the bank's customers.

How much freedom do you have over your appearance? How much do your parents or your teachers at school restrict what you can look like? Do you think that this is fair? If not, keep reading.

We in our society, in our era, have an amazing degree of freedom in how we dress and alter our appearance. You may resent the way that your parents or your teachers keep you from doing your hair in a certain way or wearing certain clothes (though just remember for a minute your own reactions to those rings, grease, and corsets), but consider how it is for young people in the tribal societies we were talking about a few pages back. The Dinka boys have no choice but to wear corsets. The Balinese girls and boys have no choice but to have their teeth filed.

You have a lot more freedom than almost anyone else in the world to choose what you want to look like, but you will have to consider the consequences of your choices. If you want a really unusual style of body decoration you may find that it's impossible to do certain kinds of work. Also, if you look really strange some people will find you interesting but a lot of other people will just think you are weird and stay away from you (and I know what I'm talking about because I was once a Punk with bright blue hair).

Make it Temporary

Remember that there is a big difference between a temporary and, on the other hand, a permanent change of appearance. If nothing else, a tattoo will limit the ways in which you can experiment with your appearance in the future.

Forever

When I was a teenager I wanted to get a tattoo. Now I'm glad I didn't because I know how much I've changed over the years. I really don't think I'd still be happy with what I might have picked back then. Now I'm an adult I still want to get a tattoo and, who knows, someday I may actually make up my mind!

Henna skin-painting is a fantastic non-permanent way to decorate your skin. Temporary tattoos and fake piercings give you the means to experiment with interesting looks without having to commit yourself to something you'll be stuck with for the rest of your life.

Do YOUR Stuff

As well as your parents and teachers, a lot of other people will want to tell you how you should look. On TV or in magazines they want to sell you this product or that and they can make it seem that unless you buy some special lipstick, pair of sneakers, or hair gel, you will look TERRIBLE.

Don't believe them. They don't know you, and body decoration in your society is all about expressing YOURSELF.

I think that really attractive, interesting-looking people create their own style rather than just copying someone else.

People look good when they are true to themselves. Whatever style of body decoration you choose, be sure that it's an outward expression of the kind of person YOU are inside.

Then you can't go wrong.

How People Change the Way They Look with Body Paint

Nobody knows exactly how long humans have been painting their bodies but it must be a VERY long time, probably for almost as long as humans have been around. When the Ancient Romans first went to Britain* the people they found there had pictures painted in blue all over their skin. When Europeans first came to North America they called the native people "Redskins" because of the red paint they wore all over their bodies.

*For Britain, see on the map.

Party Time (Bring a Pig)

On nearly ever continent there are still tribal peoples who paint themselves.

Would you like to come to a party? Bring as many pigs as you can and remember to paint your body.

If you were to live in a village of the Mendi tribe in the Mount Hagen area of the island of Papua New Guinea* you'd be invited to a yearly party lasting several days. It's called a "moka" festival and the idea is to bring lots of pigs so you can kill them, cook them, and offer the best bits to your guests. If you are an adult male and you kill lots of pigs you are called a "Big Man." If you have no pigs then you're a "Rubbish Man."

Both men and women, boys and girls are "rubbish" if they don't come to the party wearing lots of brightly-colored paint over their bodies and especially on their faces. Before a moka festival everyone spends many hours, sometimes even days, getting ready.

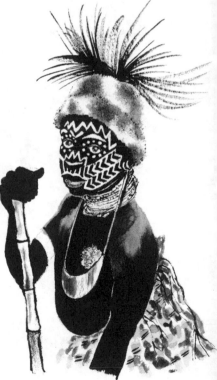

For Papua New Guinea see on the map.

24

The male elders of the tribe decide beforehand what paint colors and patterns should be used that year. For example, it might be decided that all the girls should paint their faces bright red with white and blue lines and dots around their eyes and down their cheeks, with their noses white and blue.

The men of Mount Hagen also paint their noses a bright color because they think a large prominent nose is a sign of beauty and power. They might well paint the tip bright red because it is the color of blood and they want to look like fierce warriors. To make the nose seem even brighter they put charcoal on their faces to make them very black. Then around the eyes they might paint a mask shape in white. Like noses, beards are seen as very important, and the men paint their long beards. A boy who has not yet reached the age when his beard has grown will have to paint his face in the colors used by girls.

Mixing It

Natural materials are often used as body paint. Charcoal and soot made by candles or oil lamps are used for black paint. Ashes from a fire or chalk make a good white paint. Rusty clay can be packed in leaves and burnt on a fire to make a vivid red, while the sap of certain trees can make paints which are green and yellow. To make them stick on the skin better these bright colors might be mixed with water, an egg, animal fat, dung, or even urine! Really fashionable Ancient Egyptians (see page 27) - men as well as women - used a paint around their eyes made of the crushed-up eggs of ants.

25

You don't have to go to these lengths. Just buy some good-quality theatrical face paint, a soft brush, and a make-up sponge. Then have fun (see page 28 for some practical tips).

*For Egypt see ✿ on the map.

It's Art

Around the world people use lots of different techniques for body-painting. The simplest and probably the oldest way is to use a finger, but for making finer lines people might use sticks with pointed ends. (Our equivalent would be a paintbrush.) Sometimes, as an alternative, paint is just smeared on and allowed to dry, and then patterns are made by scraping some of the paint away with a shell or with animal teeth. (Don't try this yourself because it will probably make you pretty sore.)

Another interesting idea which is used in parts of Africa is to carve a design on a block of wood. The surface of the design is dipped in paint and the design is then pressed over and over again onto the skin. You could do this with a potato half and some face paint. A similar effect can be made by painting color on a leaf and then pressing it on your skin to make a beautiful leaf pattern.

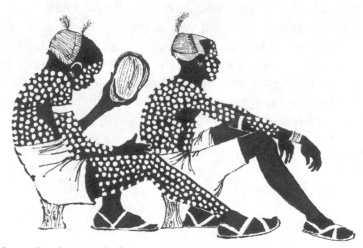

The best body- and face-painting artists always remember that the body - unlike a piece of paper - is three-dimensional. They use the shape of the face, the shoulder, the hands, and so on to shape the design. The result is to make the body look more interesting.

In the past, of course, many tribal people had no mirrors. To see what their face paint looked like they might gaze into a pot filled with water. Friends would paint each other and so everyone wanted to be friends with the boys or girls who were the best artists.

Body Paint YOUR Way

In tribes where people don't wear clothing as we do, the whole body is on display and all of the skin may be painted. In our society, where we cover most of our bodies, we've tended to focus body-painting onto the face and call it "make-up". Just as the men of Papua New Guinea use paint to make their noses more prominent, in our culture we generally use make-up to emphasize the eyes and the mouth. Once again this trend goes all the way back to Ancient Egypt when everyone, even young children and babies, wore paint around the eyes. This was to protect them from the glare of the strong sun but also to give protection from evil spirits who, it was thought, could get inside a person through the eyes.

Today we tend to think that only females should wear make-up. But why? In many tribal societies men will paint themselves even more than the women do. In Europe, until about 200 years ago, it was considered normal for men to wear make-up and to powder their faces white if they could afford it. But maybe this rather strange idea that only women can wear paint is beginning to change. At football games in Europe and in America it is popular for boys and men to paint their faces in the very bright colors of their team. This is just like the men in Papua New Guinea who paint themselves for a moka festival - and you don't need to bring a pig!

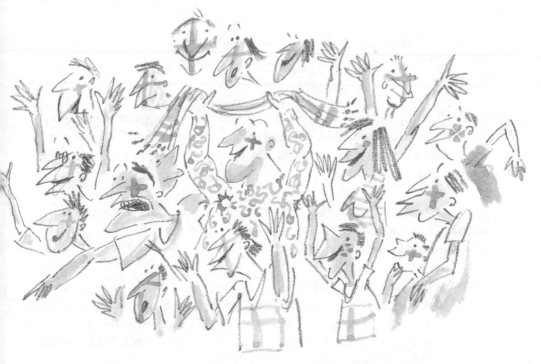

Do it Yourself Body Paint

Try these simple tips on painting your face
for a sports occasion or fancy dress.

Buy water-based face paints to use for body art. They provide bright colors and they wash off easily. They are usually sold in individual palettes or small pots.

Start by planning out your design on paper, using crayons or felt-tips to work out the colors you want. Your design is likely to look most effective if you keep it simple; for instance, by using bold lines and patterns on a plain colored background. -

For body-painting inspiration you could look in books and magazines that show tribal cultures around the world, or ,better still, investigate the art of your own native culture. Many stunningly beautiful symbols come from the very oldest examples of art.

The most creative way to express yourself with body art would be to make up your own designs that are unique to you. That would be the most effective way to show that you are one of a kind!

DO YOU HAVE SENSITIVE SKIN?

Some people have an allergy to body paint. Although water-based paints are non-toxic, don't risk using them without a skin test if you have sensitive skin. To test them, paint a small patch on the inside of your wrist and leave it for a few hours to see if a rash develops.

Your Body is Your Canvas

Don't limit yourself to your face.
Here are some effective body art areas:

STOMACH

ANKLE

ARM

LEG

HANDS

Body Painting ... How to Do it

Use some soft thin brushes for lines.

Use pieces of sponge for background color.

1 Apply background color with a damp sponge. Be careful not to make it too wet because then the paint will streak.

2 Let the base coat dry. Then, if you want the color stronger, put another coat on top.

3 If you want to blend different colors in the background, start with the palest color first and let it dry. Then add darker ones on top.

4 Take care when you paint around the eyes. If you can manage, keep an eye closed when you're painting around it.

Spend some time experimenting to get your own special effects.

Remember to take a photograph of the finished results to keep as a record of your unique art stule.

Design Styles

Animals are often used as symbols in body art. Snakes look particularly beautiful because their long fluid body shape can be made to follow the lines of the human body.

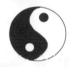

The yin and yang symbol represents perfect harmony and balance.

Mythical creatures such as dragons are popular tattoos. You could try recreating simple versions using body paint.

Patterns made of lines, spirals, dots, and simple shapes look striking.

Use black or a similar dark color to give your design a strong outline.

How People Change the Way They Look with Henna

If you make a mistake painting yourself, or you simply get bored with a body paint design you can just wipe it off.

But what if you really like a design and would like it to last longer? Thousands of years ago, somewhere in the Middle East, Northern Africa, or India somebody discovered that the leaves of a particular bush called "henna" could be made into a body paint which would leave color on the skin for a month or so. People started grinding up the henna leaves into a very fine powder and adding water (sometimes mixed with cow dung) to make a paste which could then be smeared or painted on to stain the skin a beautiful reddish-brown color.

Nowadays you can buy tubes or pots of body-painting henna ready for use (with no cow dung). Many people find that it is good for the skin, and many also believe that it offers protection from evil spirits. Even if you don't believe this, you can still enjoy its rich colors. Don't confuse it with the hair-dye henna, though. If you try to use hair dye on your skin, you'll just make a horrible mess!

What is Mehndi?

In parts of Northern Africa* and the Middle East* henna is particularly popular for painting intricate designs on the hands and the feet. One reason for this is that the Moslem women who live in these parts of the world must keep their bodies covered up for religious reasons. Sometimes their faces must be covered with a veil (except for the eyes which are often painted black). This leaves only the hands and the feet exposed and so it makes sense to decorate them.

In parts of India* it would be unthinkable for a woman to be married without intricate henna patterns painted on her hands and feet. In India henna body-painting is called mehndi (pronounced mendi) and a bride-to-be will sit for many, many hours as her friends carefully cover her feet and hands in designs of flowers, swirls and leaves. An Indian bride wears a red sari and this looks especially nice with the reddish-brown shades of the henna.

For North Africa and the Middle East see and *on the world map.*

For India, see *on the map.*

Mehndi - How to Fake It

Real mehndi decoration is very beautiful but it takes quite a long time to do and you can't remove it; you just have to wait for it to fade. If you think you might have a problem with your parents or at school this book has the answer ... fake it with a pot of henna-colored body paint! Use a fine brush to paint a pattern on hands or feet, or paint through a stencil..

There are two stencil sticker designs included with the kit attached to this book. You will need to cut out the pattern using a craft knife. Make sure that you work on a cutting mat or something similar.

You could also make a stencil by folding a sticker in half and then half again. Cut patterns into the sticker with sharp scissors. (Remember making snowflake patterns at school?)

To get a fine line you need a steady hand. It will help to rest your
painting arm on a table as you paint.

Hold the stencil firmly down as you paint through it.
Don't move it until the paint has dried.

It will make things easier if you have a friend to help you with the painting. Why not
invite your friends round for a mehndi session, just like people do in India.?

Mehndi Ideas

Here are some design ideas to inspire you!

TOES

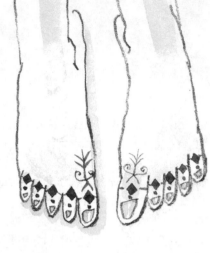

STOMACH

ANKLE

These patterns will look good!

How People Change the Way They Look with Bindis

Bindis are marks that women wear on their foreheads in parts of the world such as India where there are Hindu communities. Now bindis are often worn purely for decoration and they've become fashionable in our society, but in some areas of the world they are still symbolic.

Hindus regard the forehead as a particularly pure part of the body. The bindi is a mark of purity and it is also thought to protect the wearer from evil. Hindu women often wear a red dot, a sign of blessing. They put it on in the morning or it gets printed on when they go to their Hindu temple to worship. Traditionally the mark is made with a colored paste made from sandalwood.

Hindu men have a more complicated system of forehead marks that show to which religious community they belong.

Buddhist Baby

In the Himalayan kingdom of Nepal* specially-chosen little girls called "kumaris" are treated as goddesses until they reach puberty. The most important one is chosen every ten years from the three-to-four year-old daughters of local high-ranking Buddhist families. She must be physically perfect and undergo a long and complicated ritual to test her courage. If she passes she moves into a palace to be looked after by her mother and the priests, and she is worshiped as the embodiment of the mother goddess Taleju. She wears fine jewels, a white-powdered face and a 'third eye' painted on a red background on her forehead. (She is believed to have divine fortune-telling powers.)

One of the kumari's most important duties is to bless the King every year by marking a red dot on his forehead.

So, next time you wear a bindi you'll be able to tell your friends that you're carrying on a long and deeply-rooted tradition that has been continued for centuries.

*For Nepal, see ❧ on the map.

How People Change the Way They Look with Tattoos

In a few weeks henna designs, like body paint, will wear off. A fake tattoo can be removed easily, too. A permanent tattoo, however, will last forever. It stays permanent because the paint or ink is put deep into the skin rather than just on the surface, and it's very painful because it involves making lots of tiny holes in the skin.

In Their World

In some parts of the world permanent tattooing is a tribal tradition and is often a way of marking someone's body to show that he or she has moved forever from being a child to an adult.

In places such as Tahiti* in the South Pacific the tattoo is done with a stick fitted with sharp needles sticking out at the end. The needles are dipped in an ink (usually made from black soot or charcoal). When the needles are in the correct position, another heavier stick is used to strike the first stick - driving the needles into the skin. It is thought that the "tat tat tat" of one stick hitting the other is the origin of the word "tattoo".

Needless to say this is a painful process. In many South Sea islands, such as Samoa,* a man wealthy enough to afford it will have what looks like a pair of shorts tattooed from his waist to his knees - the whole thing made up of lots of tiny designs. A man who started such a tattoo but couldn't stand the pain and stopped would be known as a "half done." He and his relatives would feel ashamed that he had "chickened out."

*Look on the world map for Tahiti 🐚 Samoa 🖊

Further south, down in New Zealand,* the Maori people once used an even more painful way of getting a tattoo. Here the technique was to chisel long, fine grooves in a man's face and then brush ink into the open scar.

An important Maori man would have hundreds of such lines cut in delicate, swirling patterns which complemented the shape of his face. Each man's face tattoo was unique and when early explorers from Europe signed treaties with the Maori the chief would draw his tattoo design as a signature.

If the idea of having lines cut into your face makes your stomach go queasy and sets your teeth on edge, consider the way the Inuit of North America* once did their tattoos. A needle (typically made of whale bone) would have a string attached through its "eye." This thread was covered in black soot from an oil lamp. The needle would then be pushed under the top layer of skin and pulled across and out, leaving behind a black line under the skin.

* Look on the map for New Zealand 🜚 and Inuits of North America

In Your World

As you will no doubt have seen in your own town or city, people in our society sometimes get permanent tattoos. Many of my friends have tattoos. Some of them are glad they did but some are sorry. You can now have a tattoo removed by special laser treatment done in a hospital, but it's very expensive and almost always leaves a nasty-looking ugly scar.

People dislike tattoos for lots of reasons but one of the most important reasons why they aren't common in our society is because our way of life changes so fast. Fashions come and go.

One year everyone is wearing one style of clothing, fixing their hair in a certain way, and saving up to buy a particular kind of trainers; the next year everything is different. This makes it very difficult for people with permanent body decorations because the design they choose to have tattooed on their body in one year may seem really out-of-date a year later. This is a very different situation from that in the tribal societies where designs are passed down through many generations.

What Others Think

The most important thing to remember is that while you may change, a permanent tattoo will not. For example, I know one man in London where I live who fell in love when he was 19. He believed that this love was really strong and would last forever and he got the girl's name tattooed on his arm. Unfortunately, the love didn't last and now he's married to someone else with a different name from the one on his arm. (If only he had found a wife with the same name!)

I also know a woman who was a Punk when she was young and had the name of her favorite band - The Clash - tattooed on her arm. Now she isn't a Punk any more and likes other bands and other kinds of music. At least she can cover up her arm. There is a man who lives on my street who, one night many years ago, had a friend (some friend!) tattoo a spider's web on his face. Now he can't get a good job and everyone is scared of him. I asked him once if he was sorry he got the tattoo and he said: "You bet. It's ruined my whole life. Everyone thinks I'm a nut case. I guess I am. Girls all act like I've got some sort of disease."

Tattoos Can Be Dangerous

Getting a permanent tattoo can be dangerous to your health. Anything that pierces the skin and which isn't 100 percent clean - sterilized in a special machine - could pass on to you a disease from the last person who was tattooed. Some of these diseases could kill you. Trying to do a tattoo yourself is a COMPLETELY STUPID IDEA! DON'T DO IT! It is certain to look terrible and you could get all sorts of infections.

Will I? Won't I?

Earlier I said that for a long time I've really wanted to get a tattoo! Yes, it's true. A tattoo can be a beautiful work of art, one which, instead of hanging on your wall, is actually part of yourself. But I want to be sure that I've reached a point in my life when my ideas about what style of tattoo I want won't completely change. When I work this out I'm going to have the design painted on in henna so I can check that it's right. And, finally, if I'm convinced I've got it perfect, I'm going to find the best tattooist I can - one who works with 100 percent safe equipment and who is a real artist. Then I'll see if I've got the nerve for it. Having started I certainly wouldn't want to end up as a "half done."

You've got a lifetime to plan your perfect tattoo. For now you can enjoy trying out designs using body paint or henna. Or you can experiment with temporary tattoos. Have fun!

Fake Tattoos - How to Use Them

Fake tattoos should be safe for use but if you get a rash or lots of itching after you've applied one, wash it off immediately.

Don't position a fake tattoo near your eyes in case tiny pieces of the picture flake off.

DON'T WASTE THEM!
If you wear a fake tattoo to school you might get ordered to remove it. If your school has a rule like this don't waste your fakes. Wait until you're out of school before you show them off.

Use body paint to make your own fake tattoo designs. See page 34 for some tips.

HOW PEOPLE CHANGE THE WAY THEY LOOK WITH TATTOOS

1 Cut out the tattoo you want and remove the protective sheet that's on top.

2 Put the tattoo face down on clean skin.

3 Wet the tattoo for about 30 seconds.
Then slide the paper backing off.

4 After a further 30 seconds wipe the tattoo over gently.

To get your tattoo off wipe it with
a make-up removal cream.

How People Change the Way They Look with Nail Art

Did you know that your fingernails grow ten times faster than your toenails? An Indian man named Shridhar Chillal of Ponna grew the nails on his left hand to a total length of 293.5cm (115 $\frac{1}{2}$ inches) - not counting his thumb nail, which was 75cm (29 $\frac{1}{2}$ inches) long. This took him 30 years and during that time he used his right hand for doing everything.

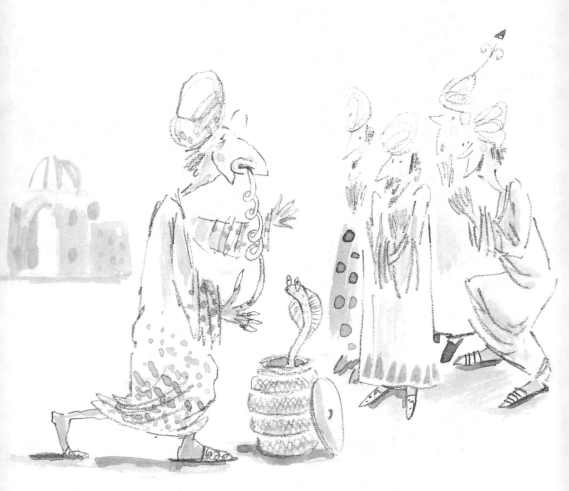

I'm Rich! Just Look at My Nails!

In Ancient China* very wealthy men and women let their fingernails grow very long and painted them with real gold. This was a way of showing that they were so rich and high-class that they didn't have to do any manual work. They had plenty of servants to do everything for them.

Many women in our own society like to grow their nails long and then paint them in bright colors. As in Ancient China, to do this shows that you don't have to do the sort of rough work which would damage your nails ... but if you do, you can always cheat. You can have short nails most of the time and then glue long, plastic nails on top of them for special occasions.

*For China, see 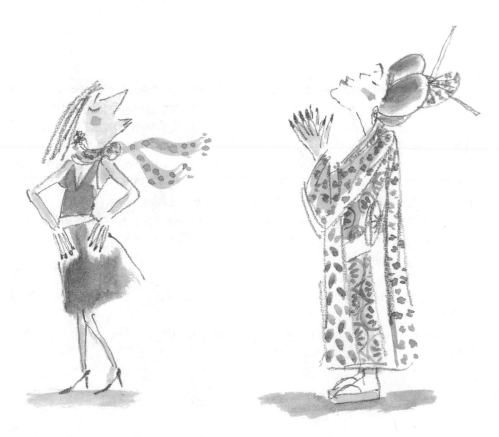 on the map.

49

Getting the Picture

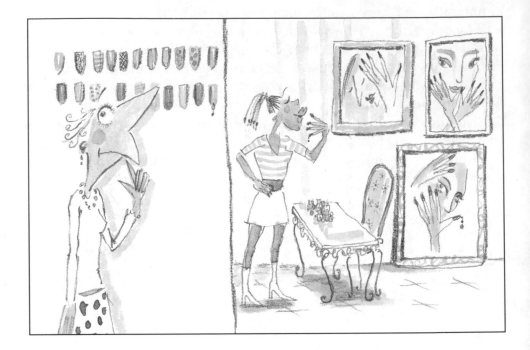

Nowadays, especially in America, even little towns have a special place where women can go to have their nails decorated. All along the walls of places like this there are thousands of fake plastic nails showing the different sort of fancy designs from which you can choose.

Once you have decided, a specialist in this art will glue long nails of whatever length you want onto your own real nails. They now use a glue which smells really terrible but which lasts a long time - several months if you're lucky. Then, using a gun which sprays color, the design that you've chosen is made by spraying over a tiny paper or plastic stencil with holes already cut out - there is a different one for each color. The result is a miniature painting, perhaps of a palm tree, the moon, stars, your birth sign, or whatever you like - reproduced on each finger.

Sometimes people have tiny holes made in the ends of their fingernails so they can attach rings or even bells!

Some Do, Some Don't

In some ways this nail art is a new form of body decoration which has only developed (and become very sophisticated) in the last 20 years. Tribal people don't usually do anything fancy with their nails. They often have to work very hard every day with their hands. The men may hunt or raise crops and the women work in their gardens or grind grain for food. Nail art would be a waste of time for them.

However, in places where people have developed specialized jobs - like being a professional dancer or actor, for example - there is more possibility for extraordinary nail art. Dancers in Thailand* have long nails and pointed cones over the tips of their fingers. These have long thin sticks coming out of them with tassels or flowers on the ends. Dancing in Thailand involves a lot of graceful finger movements and this decoration makes them even more obvious and beautiful.

I sometimes used to paint my fingernails black. People thought it was strange. I don't do this anymore but it doesn't seem fair to me that women in our society can have the fun of adorning themselves in this way but men (except some rockstars) aren't supposed to do it. What do you think? Later in the book I'm going to talk more about different body decorations for men and women, boys and girls.

*For Thailand, see 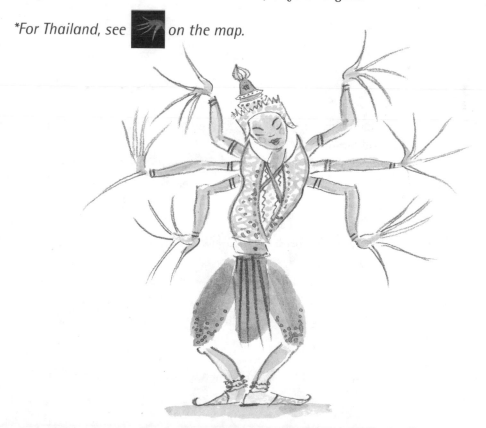 on the map.

Nail Art - How To Do It

If you are going to use your nails as an art canvas you need to keep them in good shape. Healthy eating will help, so make sure you have a piece of fruit and some fresh vegetables each day and try to drink plenty of water. Your whole body will benefit, not just your nails.

Use a sandpaper emery board to gently shape around the top of each nail and remove any rough edges. Make sure they're clean before you paint them.

1 If you want, paint your nails carefully with colored nail polish and wait for them to dry before you add pictures.

2 Cut round the nail tattoos and take off the top layer of protective film..
Lay them out ready to use.

3 Lay the tattoos on your nails. Wet each one and press it down for 30 seconds. Then peel the covering off.

4 If you want your nail art to last coat your nails with a clear protective polish once the tattoos are dry. However, make sure you only brush it on very lightly, so as not to damage your pictures.

Remove nail polish with a non-acetone nail polish remover dabbed on to a ball of cotton.

Nail Art Ideas

Paint your nails and when they're dry add nail stickers. Then put clear protective polish over the top.

Look out for nail art kits that contain shiny jewels and stars, colorchanging nail polish and lots of other new and exciting ideas.

Use a very fine *brush* to...

... paint half your nails one color. Wait for the polish to dry and then paint the other half a contrasting color.

...paint stripes of one color on top of another color.

... paint a swirl on each finger.

... paint a pale- colored heart on top of a dark-colored background.

...paint words, with one letter on each nail.

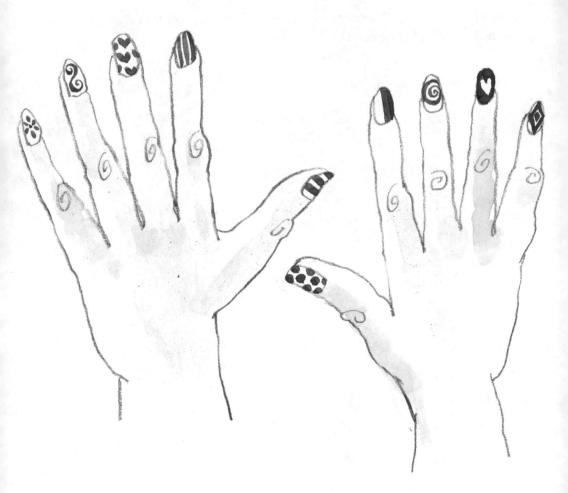

How People Change the Way They Look with Body Piercing

Over the years people have discovered lots of places where adornments and jewelry can be attached to the body. You can have flowers, beads, or combs in your hair, necklaces around your neck and metal or woven bands around your arms or legs. You could have a belt hung with jewelry, bells, or shells, or beads around your ankle and rings on your fingers and toes.

You would think that this would be enough. But so great is the human urge to decorate our bodies that long, long ago people in distant parts of the world came up with a new idea - making permanent holes in the body as attachment points for yet more jewelry. The ear lobe is the most obvious place for this. It's a silly-looking bit of flesh that seems to exist simply as a place to put earrings. So where else do people pierce? Just about everywhere you can think of. Here are just a few examples from the world map.

Piercing Traditions

For centuries Indian people have pierced the side of the nose. In some other parts of the world people found that they could make a permanent hole in the septum of the nose - that is, the part of the nose between the nostrils. Warriors wanting to look as fierce as possible to frighten their enemies may stick objects such as animal bones through the hole. I once saw a film about Papua New Guinea where a tribal man, while being interviewed, casually took out the bone in his nose and replaced it with the bic pen belonging to the European interviewer. It looked quite good - and at least you would always know where your pen was!

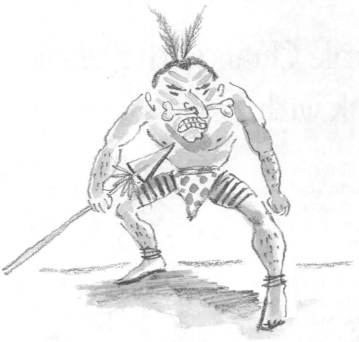

The Inuit of North America traditionally made a hole on the face just under the lower lip. This is called a "labret" piercing and you may have seen people today who have the same decoration. Although Inuit women in many areas had labret piercings, in the area in the far north above the Yukon it was only the men. The women had tattoos on their faces instead.

When a boy of the Yukon reached the age when his voice began to change and get deeper he would be taken to a traditional face-piercing specialist. He would sit on the man's lap and a piece of wood would be put in his mouth behind the place where the hole would be made. The older man would then take a knife with a blade made of slate and push it hard through the flesh and into the wood. After the cut had been washed with urine (strangely, a way to prevent infection) a small, round pin made of ivory from the tusks of a walrus would be inserted. It was a sign that the boy was thought of as a man who could learn hunting skills and look for a wife.

In the African country of Cameroon* the young women are pierced in the center and at the corners of both the lower and upper lips. The ritual happens when the girls are becoming adult women and need to be taught the "things of women." It is said that this knowledge about being a wife and a mother was first told to these people by a frog. The six plugs around the lips pull the mouth forward and are thought to make the girl look a little like a frog, which these people see as a sign of real beauty.

*For Cameroon see on the world map.

56

Big is Beautiful

If you have a hole pierced in your body and you start fitting it with larger and larger plugs it will gradually stretch. For instance, in the Suya tribe in the Amazon* a young boy will have his ears pierced and then, later, his lower lip. Bigger and bigger plugs made of carved wood or rolled-up palm leaves are inserted in the holes until eventually the ear can take a plug about 5cm (2 in) across while the lip plug is bigger than a CD!

It's much the same in the Surma tribe in Ethiopia* but here it is the women and not the men who wear enormous lip plugs. They're made of clay with a groove all around so that the greatly stretched lip - looking almost like a fat rubber band - can hold the giant plate in place. A Surma girl is first pierced a few months before her wedding. The eventual size of her lip plug will determine how many cows the groom's parents will have to give as a present to her family!

*For the Suya of the Amazon see on the world map .

For the Surma of Ethiopia see

So What About You?

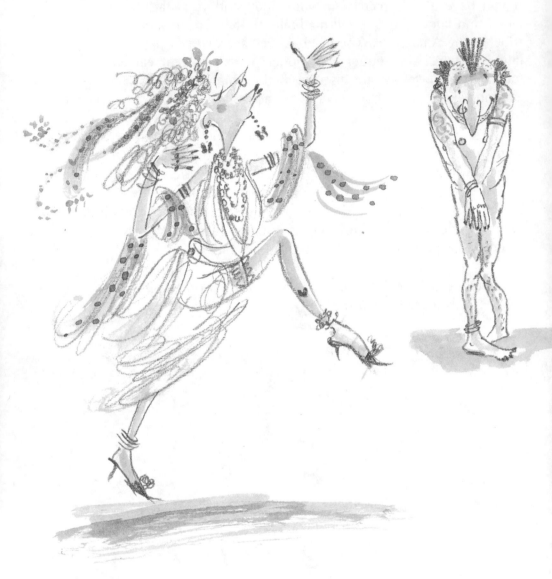

As you have probably seen, lots of people in our society are now getting themselves pierced. Nobody I've heard of so far has taken thing as far as the Suya or the Surma to have lip plugs the size of CDs. But there are some unusual piercings, in the top of the ear, the eyebrow, or the tongue, for example.

What do you think about this? I think that - as with tattoos - some of this jewelry can be very beautiful. It is certainly interesting!

But remember that a piercing is a serious thing. It is serious first of all because if done incorrectly or with unsterilized needles, it can be a source of extremely dangerous diseases and that's why you should NEVER TRY TO PIERCE YOURSELF. Even if done correctly, by someone who is a trained specialist, a piercing can get infected unless you look after it properly.

Piercing is also serious because it is a permanent form of body decoration. It's true that you can let a relatively new piercing heal over - perhaps leaving just a tiny scar. But after you've had a piercing for a while, especially as it gets stretched, it will become more and more permanently a part of you.

Give Yourself RESPECT

A lot of people are getting themselves pierced because it has become a sort of fashion - we see rockstars and people in the supermarket with them and we want to have the same. But I think that an ancient form of body decoration like this shouldn't just be done to keep up with fashion. As I've tried to explain in this book, for the tribal people who invented these extraordinary body decorations the time when you get a piercing, a tattoo, and so on should be a special, unforgettable moment in your life. It's not just something to do on a whim. Treat your body with respect. It's the only one you've got.

Piercing Jewelry- How To Use Fake Piercings

Never use fake piercing jewelry on your nose, in case it slips inside. Use a jewelry sticker or a bindi on the side of your nose instead.

How to care for a piercing

If you have your ears pierced you need to take good care of the piercing for a while to prevent it becoming infected.

ALWAYS go to a recognized piercer who has the right equipment and is trained to use it.

The piercer will anesthetize your skin before he or she pierces it and then will insert a ring or a stud. Ideally this should be made of gold because it is less likely to cause infection than other metals.

Gently bathe your piercing and ring or stud twice a day with cotton soaked in salt water. Each time apply a little teatree oil to prevent infections.

Don't keep touching your piercing. Your hands won't be clean and you could well cause problems.

Once your piercing seems to have healed up well you can stop bathing it.

If your piercing does get infected remove the ring or stud and treat it with an antiseptic. Don't replace the jewelry until the infection has gone.

Scarification - What It's All About

(and why you shouldn't try it)

It would be wrong to do a book about body art without talking about scarification, a body decoration used by many tribal African peoples. I'm going to explain it, but I'm also going to say strongly and up-front that it would be a disastrous and highly dangerous thing to try. The tribal peoples who practice scarification in Africa know what they are doing. Over many generations these techniques have been perfected so that they are as safe as possible. NO ONE in our society has these skills and this knowledge.

Scarification involves making lots of cuts on the skin and when the cuts heal the scars remain, forming a design. Sometimes charcoal is rubbed in to make the scars more obvious and occasionally small stones or even pearls are put under the skin so that when the cut heals it looks really bumpy.

The Sudanese Nuba* people practice scarification. The young Nuba men are famous for extraordinary body-painting and hairstyles that we'll talk about later (see p82). Nuba girls and young women also paint their bodies, rubbing one color all over (a specific family color worn by all members of one family). In addition they get patterns of scars. A young Nuba girl receives her first set of scars when her breasts first begin to develop. This is done by one woman in each village who is a specialist. The girl to be scarred will pay the specialist by grinding up some grain for her, or perhaps giving her a load of firewood. Alone, up in the mountains, the specialist begins her work, using a hooked thorn and a small blade to produce a scar pattern between the chest and the belly button.

Later, when a Nuba girl develops further, she gets another set of scars on her torso. Then, after she has had her first child, she will get lots more on her back, legs, arms, and neck. This final set costs a lot of money and the woman's husband will be expected to pay. If he doesn't, the woman will look for another man to pay the specialist and he will become her new husband.

All her life a Nuba woman will wear her scars with great pride. To us it looks a if she has really big goose bumps. To her it is an essential mark of beauty.

* For the Nuba of Sudan see on the world map..

Give Others Respect

Does this scarring seem strange to you? I expect that most people in our society would think the scarification designs ugly rather than beautiful. I did too, when I first saw them. But remember, as we've seen earlier in the book, different groups of people often have completely different ideas about what is attractive and what is a good way to decorate the body.

We Should Respect Other People's Ideas About Beauty

People who come from tribes where scarification is normal might think that you and I look really unattractive, even strange. We wouldn't want people to make fun of us because of the way we look so we shouldn't make fun of people who look different from us, though that's not to say we should go ahead and copy them.

Do you ever get made fun of at school because of the way you look? Do you ever make jokes about the way someone else looks, dresses, or fixes his or her hair? When I was young, my family didn't have much money and sometimes I got laughed at because I didn't have all the latest fashions. I used to get upset, but now that I'm older I know that the kind of people who only want to be your friend if you look a certain way are not the kind of people who are real, true friends. Get to know people who like YOU, whichever way you want to decorate yourself.

Why People Decorate Their Bodies

Do you think that decorating the body is a silly thing to do? I don't. You probably don't either, since you've chosen to read this book. Certainly all the different tribal people we've been talking about don't feel this way. They believe that body decorating and body jewelry of various kinds is an important part of their lives. More than that, they believe it is necessary to make them complete human beings.

So what's so important to them about decorating the body? Why do they spend large amounts of time changing their appearance? The obvious answer is that they do it to make themselves more attractive. We all want to look good and, as we have seen, different groups of people have different ideas about what is beautiful or handsome and different ways of changing their body appearance to bring themselves closer to their ideal. This is why the Balinese have their teeth filed flat, why the girls of the Nuba tribe have bumpy scars put on their skin, and why the boys of the Dinka tribe wear tight-fitting colorful corsets.

But if you thought that beauty was the only reason why people change their appearance you would be wrong. It's just the beginning of the story. Here are some interesting reasons from around the world. Compare them with the reasons why you and your friends dress and body-decorate the way you do.

Watch Out, I'm Nasty

Imagine that you are a fierce tribal warrior going into battle. You will need a good weapon - a spear or a bow and arrow, perhaps. But it would also be a good idea to look as nasty, terrible, and brave as possible. If you can frighten your enemy into running away then you've won easily!

This is the idea behind warpaint and other body decorations which warriors use to make themselves look as fierce and menacing as possible. For instance, the men of many North American Indian tribes once painted themselves red - the color of blood and also a bright color which proved that they weren't afraid and trying to hide.

In parts of Papua New Guinea some tribes were constantly at war with each other until quite recent times. Trying to look as horrible as possible was an important part of this fighting. The warriors smeared their faces and bodies white to make them look like ghosts and evil spirits. In addition, they wore huge bones or other objects through their noses to show that they were brave and did not fear pain. If these guys

came charging over a hill, shrieking and shouting and waving their spears, most of us would run the other way!

The Maori tribes of New Zealand saw their facial tattoos as beautiful. Yet they also knew that in battle these strange swirling patterns could look very frightening and they grimaced and stuck out their tongues to make themselves even scarier.

Even modern rockstars from our own society sometimes use facepainting to make themselves look menacing and rebellious.

I Belong

Although in our society we no longer live in tribes, our ancestors did, and they discovered the importance of each tribe having its own style of body decoration. Think of a football game; if both teams wore the same colors it would get very confusing! It's a very sensible and practical idea for your team - or your tribe - to have its own unique visual identity.

Imagine, thousands of years ago, two tribes living in the same part of a jungle. The members of one tribe decide to paint their bodies with red stripes. The others decide to paint their bodies with blue dots. Instantly everyone knows to which group everyone else belongs. Even more importantly, everyone feels a sense of pride and community when they put on their "colors."

So, far from being silly and a waste of time, body-decoration for our ancestors gave an important sense of comradeship and the feeling of being part of the same community. It has played an important part in the development of human life, including yours and mine.

Like our tribal ancestors, we also like to use our body decoration to show our similarities to our friends and those we admire. For example, a group of boys might all want to have the same hairstyle, or a group of girls might all choose to wear the same style of make-up. If the style of a famous rockstar or actor is copied, thousands, even millions of fans all over the world use their body decoration to show that they are all a kind of huge, modern "tribe."

Looking Your Age

Have you noticed how often a person's age determines his or her style of body decoration? Think about the Nuba girls who we talked about earlier. At each stage of their lives they are allowed to have a different set of scarification designs. Or consider the males of the Amazon Suya tribe (see page 57). They get piercings in their ear lobes and in their lower lip when they are boys but it is only when they are a bit older, ready to become adults, that the piercing in their lower lip is stretched

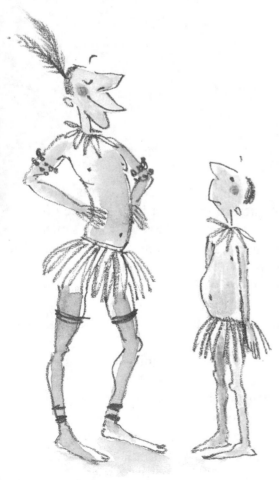

with bigger and bigger round plugs. It is only when their lip plug is about the size of a CD that they are considered to be grown-up adults.

In both cases, you only have to look at people's body decorations to know what stage they are at in their lives. So, as well as instantly showing what tribe you belong to, body decoration can also instantly show how old you are.

To a certain extent, the same thing happens in our own society. A 12-year-old girl wants to wear make-up but her mother says: "Not until you're older." Maybe a boy of the same age wants to have a particular style of haircut but his parents tell him he must wait until he's older. I think this is good. By saving certain body decorations for when we are older we make them part of a celebration - a marker - of our having finally reached a certain age.

In almost all tribal societies there are some body decorations which are prohibited until a boy or girl becomes an adult. This makes it possible to have a really special occasion to mark the different stages of growing up. When they reach the age of eight, boys of the Panare tribe of southern Venezuela* are allowed to wear tall red feathers, armbands made of beads, necklaces made from monkey's teeth, and a woven straw belt which hangs down to cover their genitals. When they are old enough to marry, they are also able to wear leg bands made from the hair of their wife.

*For Venezuela see on the map.

A friend of mine who grew up in a small village in Ireland* tells me that something similar happened to her. "After I'd had my first communion in the Catholic Church I was then taken by my mother to the chemist shop where I had my ears pierced. This happened to all the girls in my village. It was a kind of initiation rite - a visible sign that we were now grown-up."

*For Ireland see on the map.

Showing Off Who You Are

As well as showing how old you are and what tribe you belong to, body decoration can also signal in some detail who you are, and sometimes how important you are. For example, in many North American Indian tribes a man was only entitled to wear face paint if he had killed an enemy in battle.

The Nuba girls whose scarification designs we've already talked about also smear their bodies with clay of different colors. What family you belong to - your clan - determines your color. A Nuba man cannot marry a woman from his own clan and this "color-coding" gives him a ready reminder of who's available or who's not available.

It's also a sensible idea to show people if you are married or single. In our society we have long done this by wearing a ring on the second finger of the left hand. But there are other ways. In the northern part of Japan* live an ancient people called the Ainu. When an Ainu woman married she was tattooed on and around her lips, as if someone had gone a bit overboard with a blue lipstick (only permanent). So, big blue lips = married. No blue lips = single.

If this seems strange you might be interested to know that a few hundred years ago men in Europe had tattoos which showed their professions. Masons had trowels, bakers had the scoops they used to get the bread out of the oven, and miners had tattoos of the lamps they wore on their heads in order to see underground.

Body decoration is a kind of language. It allows us to "read" a person as we would read a book. Maybe you could use your choice of body decoration to give other people some idea of what kind of person you are. It sounds easy, but do you know what you want your appearance to say? That's much harder to work out.

*For Japan, see ⬚ on the world map.

71

Magical Marks

In many parts of the world body decorations are also valued because it is believed that they have some magical, spiritual, or religious power which can help to protect the person who wears them. For example, the Berber people who live in parts of Northern Africa* fear that evil spirits can get inside a person through the nose, eyes, or mouth. To guard against this they tattoo patterns of dots or lines on their faces. They believe these patterns protect a person by frightening away evil spirits.

In a similar way, in the Yemen*, a mother will write "Allah" (the Arab name for God) on their baby's forehead to provide spiritual protection.

Some people believe that body decorations can give those who wear them magical powers. In the Ivory Coast of Western Africa* a woman may paint around her eyes with a mixture of white clay, herbs, and water from a river which is believed to be sacred. She does this in the belief that it will give her eyes magical powers to see beyond the normal world into the world of the spirits.

*For North Africa, see ▤ on the world map. For the Yemen see ▦ and for the Ivory Coast see 🔶

The Latest Fashions

Living in a tribe is very different from our way of life in cities, suburbs, towns, and villages. This is especially clear in our different attitudes towards body decoration.

In a tribe there is very little freedom for personal, individual choice in appearance. The girls of the Nuba tribe get their patterns of scars and paint their bodies a certain color because that is what their mothers did - and their grandmothers, their great-grandmothers and so on. In the same way, the boys of the Suya tribe in the Amazon have their lips pierced and stretched with bigger and bigger plugs because that is the way it has always been done in their tribe.

Tribal peoples are traditional - that is, they live according to rules set down in very ancient times. For this reason their way of life changes only very, very slowly. If we got in a time machine and went back hundreds, perhaps even thousands of years, we would probably find that the ancestors of the modern-day Nuba and Suya people were living their lives and decorating their bodies pretty much as they do today.

In our society, on the other hand, things change VERY quickly. When I was a kid (in the late 1950s and early 1960s) no one had computers or skateboards. People dressed very differently. (For example, no one wore sneakers except when they were actually playing sports.) Hairstyles were different too. Like most boys my age I had what was called a "flat top" with really short hair which was cut as flat as a board on top with a sort of straight up "cliff" of hair over the forehead which was kept in place with wax.

73

Women wore different colors and styles of make-up than they do today. For example, women never wore anything except red lipstick. The idea of wearing white, orange, or black would have been seen as too extraordinary and weird.

Unlike tribal people we have fashion - the idea that each year there are new colors of make-up, new ways to fix your hair, new styles of shoes and clothing. Of course you don't have to follow the latest fashions. (And personally I think that only really silly people dress and decorate themselves in the latest fashions without thinking about what colors or styles are right for them.)

But, however much we may or may not try to resist going along with the latest fashions, the fact of the matter is that it is very, very unusual for people in our world to dress and decorate themselves in the same way for their whole life. This is why, unlike tribal people, we have problems with permanent kinds of body-decoration such as tattooing.

Keeping Up With Fashion

I like to think that I'm the sort of person who is not controlled too much by fashion. And yet if I look back on my life I see that the clothes I like to wear, the way I cut or fix my hair, and so on have all kept changing all the time. When I was 20 years old I was a hippy with hair all the way down to my waist.

When, six years later, I became a Punk. I cut my hair short and dyed part of it bright blue. You can do that sort of thing with hair because it just keeps growing and growing. But if I had got a tattoo when I was a hippy, I'm sure it would have been something that looked really embarrassing when I decided to become a Punk!

Temporary types of body decorations - hairstyles, make-up, henna designs, jewelry, and so on - have the advantage that you can keep changing them.

75

And that means that - if you want - you can keep up with the latest fashions.

One thing is sure, whatever you decide, just like our ancestors thousands of years ago, or just like tribal people today, you will be using your appearance to show other people important things about yourself.

Because body-decoration is a language - an instant, visual way of expressing ourselves - it is never just a silly waste of time.

Males and Females – Who Gets to Decorate?

Animals have lots of different ways of attracting a mate. Some use smell. For example, the female silk moth produces tiny amounts of a sort of perfume which male silk moths can smell as far as 8km (5 miles) away.

Some animals use sounds. That's why most birds sing; like rockstars, the best singers are in big demand with the opposite sex. Many animals use the visual display of their bodies to attract a mate. One especially interesting example of this is the firefly, which can actually make its body glow in the dark. The female fireflies stay resting on the ground while the males buzz around flashing a sequence of long and short bursts of light. Each species has its own, unique sequence. When the females on the ground see the right sequence of flashing light they flash back to show where they are.

Both male and female fireflies have a way of signalling to each other but, more often than not in the animal kingdom it is only the male that advertizes himself. Among many birds, for example, it is only the males which are good singers or which have bright, beautiful, highly-visible feathers. The most spectacular example is the male peacock. When it spreads its enormous tail feathers to impress a female peahen it becomes one of the most impressive sights in the animal world.

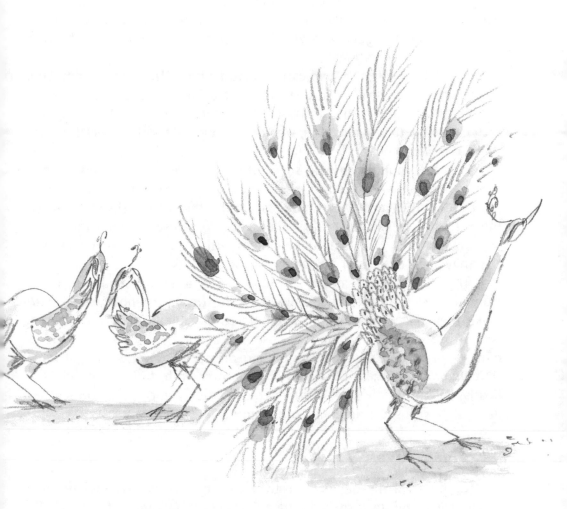

In our society it is more likely to be the other way around, with females using bright colors of make-up, nail polish, exotic hairstyles and fancy flashy clothes to show themselves off. We would be wrong, however, to think that this way of doing things is something about human beings which is natural, fixed, and unchangeable. While the male peacock is always the show-off, in the world of humans it can be either females or males. It all depends on the culture or the time in which you happen to live.

Another Great Party

Are you ready for another party? Good. Let's all go to West Africa* for a dance. Well, actually, only the boys get to dance. The girls, like female fireflies, sit on the grass and watch the boys dance and show off their fantastic body decorations.

The Wodaabe People herd cattle in West Africa. They are nomads who, in the dry season, split up into small, isolated family groups. In the rainy season, however, when the grass is rich enough to support all their cattle, they come together in one place where they celebrate with a special festival called the *Geerewol*, which lasts for seven days. (Now, that's a real party!)

It is the young men who spend the most time - hours and hours - getting ready for the festival. First they shave their hair back on their foreheads and then they carefully plait each other's hair. They use one of the earliest forms of make-up, called kohl, to blacken around their eyes and on their lips. They paint their faces with a yellow powder and over this they paint designs of red circles and white dots.

They also like to paint a line in white or a lighter shade of yellow from the top of the forehead down to the tip of the nose in order to make their noses look as long and thin as possible. (The Wodaabe feel very strongly that only long, thin noses are attractive - so much so that a mother will spend hours gently pulling on her baby's nose in the hope that this will lengthen it.) Finally they wrap a white turban around their heads and on each side of their faces, they hang strips of leather decorated with shells and brass ornaments.

*For West Africa see on the map.

Each day of the *Geerewol* festival, in the afternoon, the young men of the Wodaabe do a special dance. Standing on tiptoes for hours (in order to look as tall as possible) they roll their eyes and hold their lips apart in a kind of fixed grin. This is because the Wodaabe believe that (as well as a long, thin nose) an attractive man should have very large and very white eyes and teeth.

While the young men do their stuff, the Wodaabe girls sit holding parasols to protect themselves from the sun. After seven days of the festival each young woman picks the male dancer she thought was most beautiful and charming. If they get on well they will become husband and wife.

The young men of the Wodaabe are rather like peacocks. It is the males who are the most visually exciting and attract the attentions of the females. Far from being strange and unique, the Wodaabe way is typical of most tribal societies.

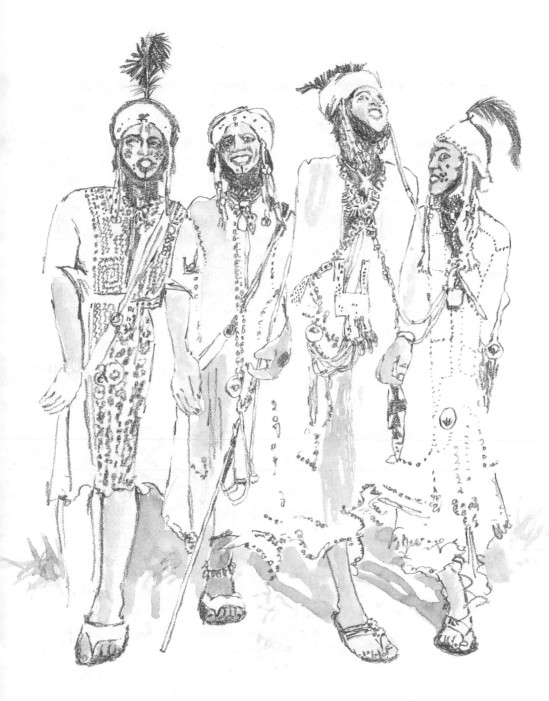

Remember the Nuba tribe of the Sudan where the girls get patterns of scars cut into their chest and back? Well, now I'm going to tell you about the Nuba boys and men who are famous throughout the world for their beautiful body-painting.

Every day, while the females of the Nuba tribe just quickly smear their bodies all over with their family color and a bit of animal fat to make them look shiny, the males spend hours and hours painting intricate designs all over their bodies. (The Nuba only wear clothing when they are old.) They might paint the shape of a bird as if it is flying across their face. They might take a woodblock which has a design carved on it and cover their own or their friend's bodies with this pattern over and over again. Perhaps they might draw a line down the middle of their bodies from top to bottom and then paint each side in a different color. They may paint a different design every day, but only using the colors and patterns which are permitted for their age-group.

Nuba men also like to have a friend cut their hair really short (to a length about the thickness of a pencil). This is then colored with bright dyes. Other parts of their heads may be shaved completely right down to the scalp to make interesting patterns that contrast with the brightly-colored hair. They may also glue feathers in a strip from front to back in the middle of their heads - a style which, to our eyes, makes them look a bit like Punks! At night, to protect their fancy hair styles, Nuba men will sleep on a special bed with their heads sticking out over the end so that they will not mess things up in their sleep.

Throughout most of human history men have been like peacocks, painting and decorating themselves while the women of their tribe, typically, look a bit less exciting. Even in Western society a few hundred years ago men spent as much time as women fixing their complicated wigs and powdering or painting their faces. Then, gradually, people started to think that only females should decorate themselves; that only girls and women should wear make-up, fingernail polish, and fancy fabrics in bright colors.

Painting Men's Faces

In the last 30 years or so we have seen a few daring male rockstars such as David Bowie or Boy George wearing paint or make-up on their faces. This has made a lot of people wonder if, like women in our society, males shouldn't have more freedom to experiment with body art and to wear brightly-colored and interesting clothes. If sometime in the future, males in our society became more like peacocks, do you think that this would be a good or a bad thing?

Of course even now it is OK for males to dress up and paint themselves on a few special occasions. We have already mentioned how at football games you now see a lot of men with their faces painted in their team's colors.

At a Halloween party everyone, male and female, can dress up in all sorts of crazy ways. The same is true at a carnival. For example, every year in the Notting Hill district of London there is a carnival where you can see lots of people - young and old, male and female - dressed, painted and decorated in all sorts of interesting ways. The same is true at the huge carnivals which take place every year in Venice (in Italy), in Rio de Janeiro (in Brazil), and in New Orleans (in the United States).

Taking a Holiday From Yourself

Sometimes dressing up and decorating your body is like taking a holiday from being your usual self. If your parents say it's OK, maybe you could have a party where you and all your friends can paint and decorate each other.

Put out some face paints and soft brushes, bindis, fake tattoos, and nail art materials. Maybe you could ask your friends to each bring something for body-decorating.

I think that people - boys and men as well as girls and women - should all occasionally have a chance to paint and decorate themselves in crazy ways. As we have seen, body art has been a means of self-expression throughout human history. It seems very boring to me that now males should feel that body art is something which only females can do. Shouldn't all people, at least on some special occasions, have a chance to express themselves in this way?

At the same time I think it's wrong if girls and women feel that they MUST wear make-up and dress in fancy ways. Some women enjoy doing so. Some don't. Just as males should be free to wear bright colors, jewelry, even make-up if they want, females shouldn't feel any pressure to do these things.

We're All Different

As I've tried to show in this book, unlike other animals, human beings can choose how they want to look. Unlike the tribal people we've talked about, you have an amazing freedom of choice and this freedom increases as you get older. This is very exciting. But remember, whatever you choose to look like will influence the way other people respond to you. For example, anyone who chooses to break the "rules" of what most people think males and females should look like, may get teased or even rejected for many jobs. It will be up to you to decide if you want to risk this for the sake of a more unusual appearance.

The most important thing is that you create a style that is really you - not just buying clothes, shoes, make-up, and so on which some company is going to make a lot of money out of selling to you. Use your appearance as an advertisement for yourself - the real you.

I hope that **Body Art** will help you get your own personal message across, whatever it is and however it may change as you live your life.

KEY To map on pages 92-93

= Skin-greasing, Ghana

= Teeth-filing, Bali

= Gold tooth adornment, Inca Empire, Andes Mountains

= Neck-lengthening, Padaung peoples, Myanmar (Burma)

= Hair decoration with clay, Hamar peoples, Ethiopia

= Corset- wearing, Dinka peoples, Sudan

= Neolithic tattooing, Alps

= Ancient body- painting, Britain

= Body- painting, Mount Hagen, Papua New Guinea

= Ancient face- painting, Egypt

= Henna painting, North Africa

= Henna painting, Middle East

= Mehndi (henna) and bindis, India

= Tattooing, Tahiti

= Tattooing, Samoa

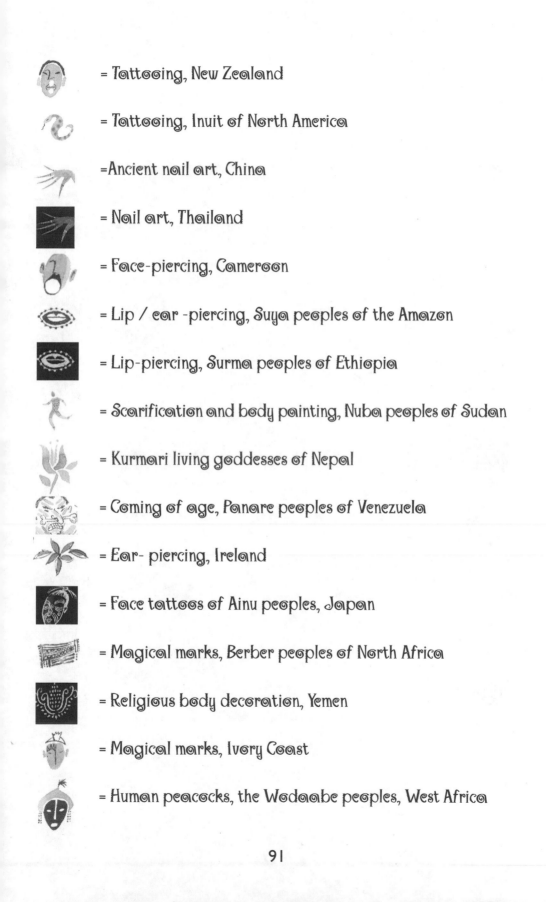

= Tattooing, New Zealand

= Tattooing, Inuit of North America

=Ancient nail art, China

= Nail art, Thailand

= Face-piercing, Cameroon

= Lip / ear -piercing, Suya peoples of the Amazon

= Lip-piercing, Surma peoples of Ethiopia

= Scarification and body painting, Nuba peoples of Sudan

= Kurmari living goddesses of Nepal

= Coming of age, Panare peoples of Venezuela

= Ear- piercing, Ireland

= Face tattoos of Ainu peoples, Japan

= Magical marks, Berber peoples of North Africa

= Religious body decoration, Yemen

= Magical marks, Ivory Coast

= Human peacocks, the Wodaabe peoples, West Africa

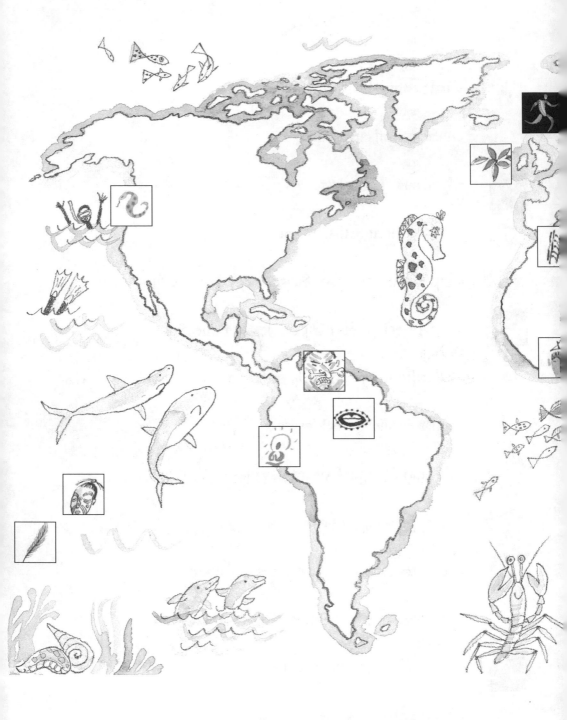

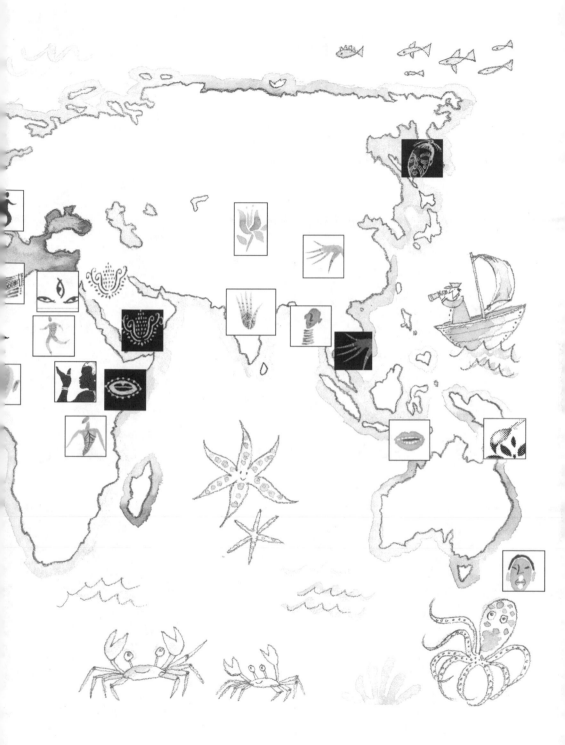

MEHNDI IDEAS
Why not try out some Mehndi Hand-painting ideas on paper first?

LEFT HAND

MEHNDI IDEAS
You could photocopy these pages
if you don't want to draw in this book.

RIGHT HAND

95

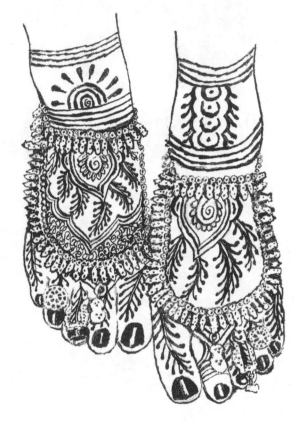